you
&me
are so nice
together

Celebrating
Friendship in Words
and Pictures

ILLUSTRATIONS BY
Artists of Marlena Agency

FOREWORD BY **Lydia Denworth**

Storey Publishing

The mission of Storey Publishing is to serve our customers by publishing practical information that encourages personal independence in harmony with the environment.

EDITED BY Liz Bevilacqua and Lisa H. Hiley
ART DIRECTION AND BOOK DESIGN BY
 Carolyn Eckert
TEXT PRODUCTION BY Jennifer Jepson Smith
COVER ILLUSTRATIONS BY Kasia Bogdańska
 (front); Lydia Mba (back); Asia Pietrzyk (spine)
INTERIOR ILLUSTRATIONS BY André da Loba, 3;
Carole Hénaff, 132; Pep Montserrat, 1;
all others credited on facing page to illustration

Storey books are available at special discounts
when purchased in bulk for premiums and sales
promotions as well as for fund-raising or educa-
tional use. Special editions or book excerpts can
also be created to specification. For details, please
call 800-827-8673, or send an email to sales@
storey.com.

STOREY PUBLISHING
210 MASS MoCA Way
North Adams, MA 01247
storey.com

Printed in Malaysia through Asia Pacific Offset
10 9 8 7 6 5 4 3 2 1

Library of Congress Cataloging-in-Publication
 Data on file

DEDICATION

This book would not have come about without my father, Wiesław, who suggested this topic when I was looking for a new subject to be illustrated by our artists. For my dad, friends were his life. As a child living in Warsaw, I remember that our small apartment was always crowded with people. Family friends would join us for dinners, bridge, picnics, and political discussions. Friends would often drop by spontaneously in good times and bad. My father's dearest friend lived far away, yet the two of them maintained their close bond over 50 years of continual correspondence. I am grateful to have had this regard for friendship modeled in my home.

I would also like to thank my dedicated team at Marlena Agency and all our brilliant artists whose talent is on display in these pages; my friend Marsha who has provided editing assistance on this and other projects; and Liz Bevilacqua at Storey who encouraged and steered us through the publishing process. While working on this project I often found myself thinking about my friends and how lucky I am to have them. I hope this book will inspire you in a similar way.

—Marzena Torzecka, Marlena Agency

Friendship Is Universal

There is no society that does not know it, no language that does not speak of it. Granted, there are cultural and individual differences in our expectations. But human beings around the world are remarkably consistent in our sense that a friend is a steady and reliable presence, a friend makes us feel good, and a friend offers help, especially in times of crisis. The words we use to describe our friends vary—brother, soul mate, bestie. Some of us open our friendship circles wide, and others are very particular about who makes the cut. Some of us embrace the "friendship" of social media; others eschew it. But few of us—very few, in fact—have never had a friend.

There is a reason for that. Long thought to be a cultural phenomenon, friendship turns out to be in our biology. It is part of our evolutionary story and as essential to our health as diet and exercise. I spent years in the company of many of the scientists who figured this out, and I told the story of their work in my book *Friendship: The Evolution, Biology, and Extraordinary Power of Life's Fundamental Bond*. Did you know that deep in the folds of your brains, you and your closest friends process what you see and hear in remarkably similar ways? So much so that neuroscientists can use brain scans to predict who is friends with whom. What I find so remarkable about that discovery is that it allows us to appreciate anew the wonders of friendship (not to mention the wonders of modern technology) and at the same time it speaks to something we have known for thousands of years. Aristotle

recognized that similarity was part of the chemistry of friendship, though even someone as wise as he presumably did not imagine just how deep those similarities would turn out to run.

That observation of Aristotle's is just the kind of thing you will find in this book. In fact, Aristotle features in these pages more than once. Through the years of writing my own book, I regularly turned to the words of philosophers, poets, and novelists for inspiration. How wonderful to have so many of them gathered here—from Cicero, Seneca, and the Persian poet Rumi to Margaret Atwood, Toni Morrison, and even Groucho Marx. The words are accompanied by an intriguing set of beautiful, evocative illustrations. Some of the words were familiar to me, some were new, but all of the art was made for this book.

As I turned each page, I found myself in delicious anticipation. The artists' interpretations of the words surprised and resonated. These pages echo what I know about friendship from my life and from my work and I am certain they will do the same for you. In a moment when the world is emerging from a difficult time of disconnection, *You & Me Are So Nice Together* serves as a potent reminder of the persistent power of friendship. Linger with it. And then call a friend.

—*Lydia Denworth*
author of *Friendship: The Evolution, Biology, and Extraordinary Power of Life's Fundamental Bond*

Friendship actually
is a matter of life and death.
It is carried in our DNA,
in how we are wired.
Social bonds have the power
to shape the trajectories of our lives.
And that means friendship
is not a choice or a luxury;
it's a necessity that is critical to our
ability to succeed and thrive.

—*Lydia Denworth*

ILLUSTRATION BY GÉRARD DUBOIS

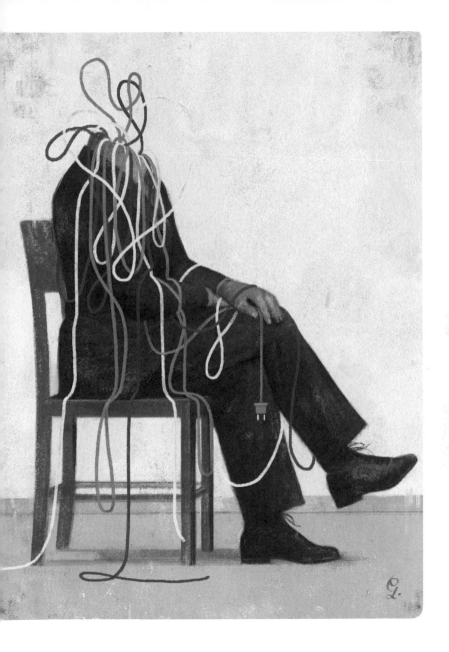

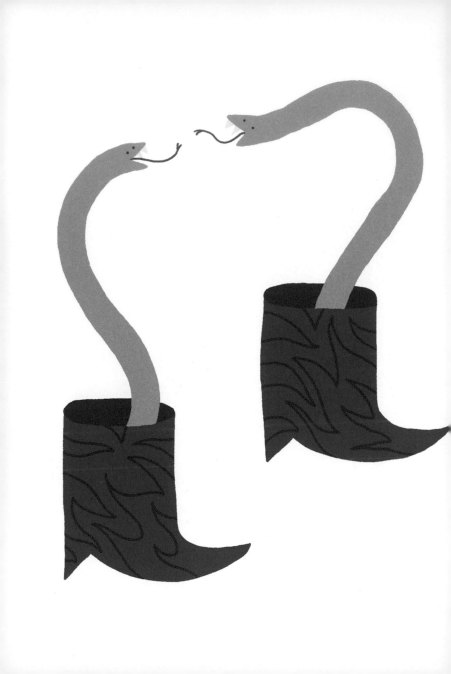

Friends share.

WORDS AND ILLUSTRATION BY ALBERTO LOT

Friendship
redoubleth joys,
and cutteth griefs
in half.

—*Francis Bacon*

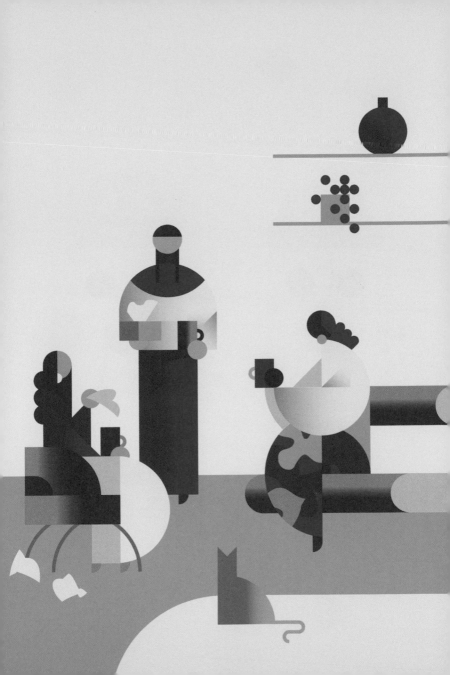

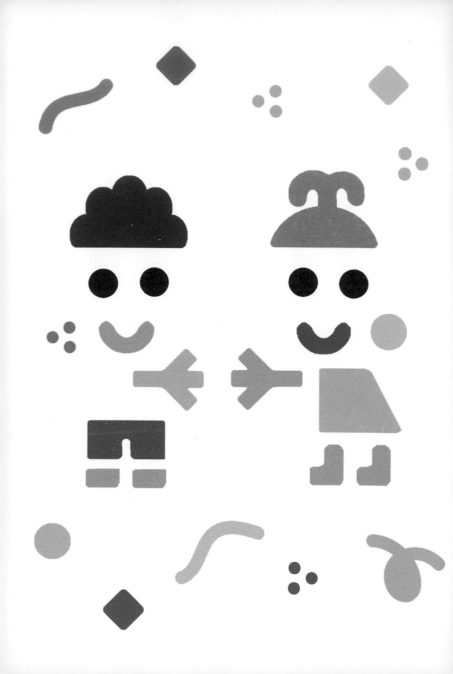

The best time
to make friends
is before
you need them.

—*Ethel Barrymore*

ILLUSTRATION BY MIGUEL ORDÓÑEZ

Friendship grants us
the privilege to talk nonsense
and invent things
without fear of being questioned
or judged.

—*Juraj Horniak*

ILLUSTRATION BY LASSE SKARBÖVIK

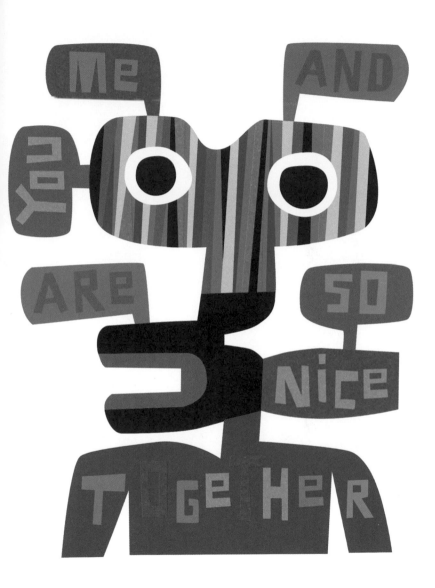

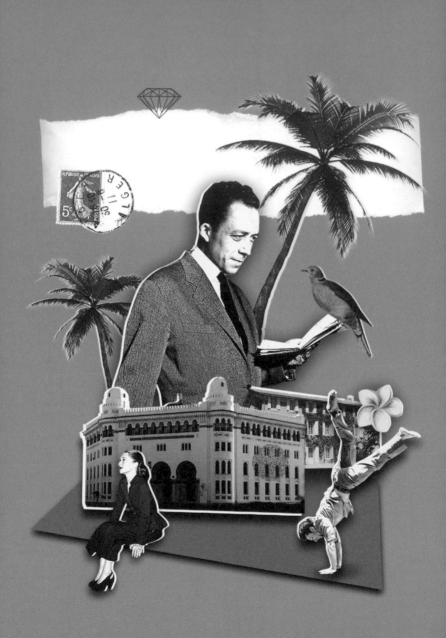

The older I get, the more I find
that you can only live with people
who set you free, and who love you
with an affection as light to carry
as strong to feel. . . .
This is how I am your friend.
I like your happiness, your freedom,
your adventure in a word,
and I would like to be for you
the companion
of which one is always sure.

—*Albert Camus*

ILLUSTRATION BY ISABEL ESPANOL

Though we meet but once,

even by chance,

we are friends for life.

—*Japanese proverb*

ILLUSTRATION BY MARIKO JESSE

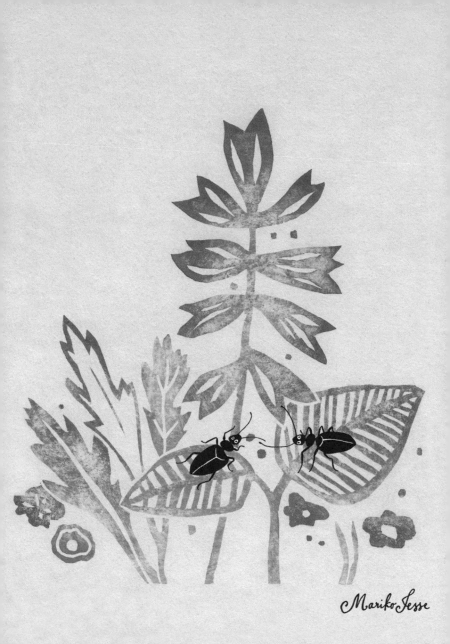

Mariko Jesse

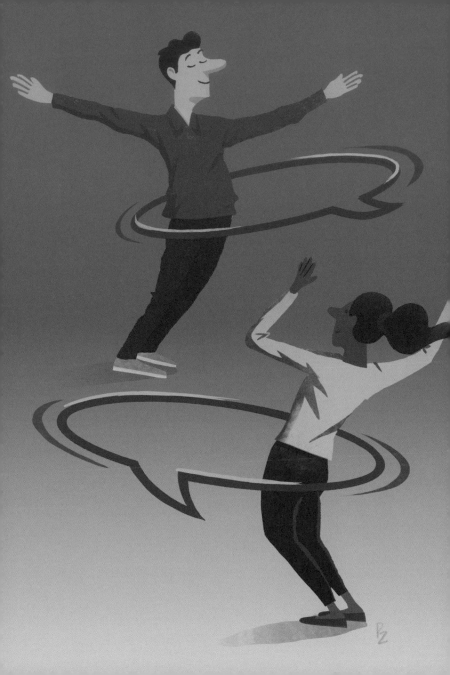

Ultimately the bond
of all companionship,
whether in marriage or in friendship,
is conversation.

—*Oscar Wilde*

ILLUSTRATION BY PAUL ZWOLAK

Let us be grateful

to people

who make us happy,

they are the

charming gardeners

who make our souls

blossom.

—*Marcel Proust*

ILLUSTRATION BY FEDERICA BORDONI

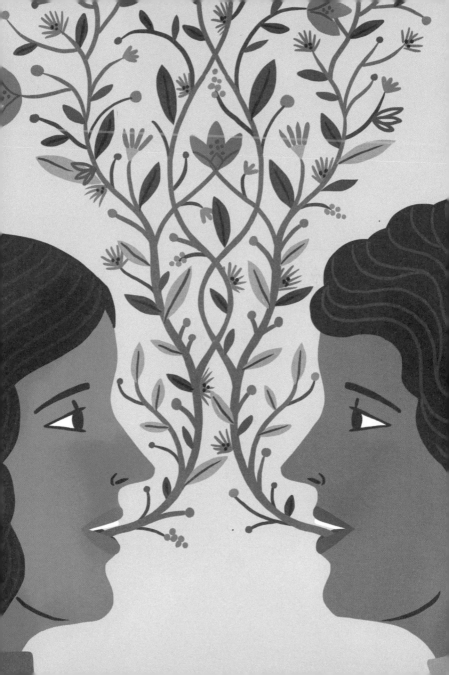

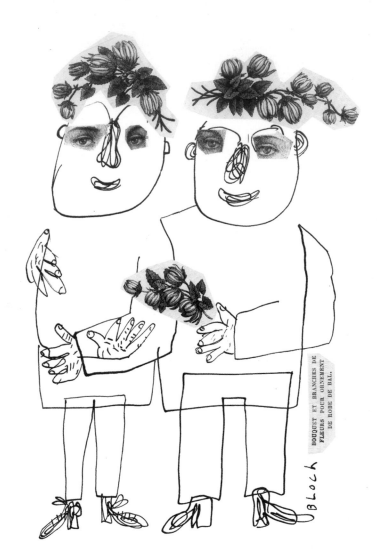

BOUQUET ET BRANCHES DE
FLEURS POUR ORNEMENT
DE ROBE DE BAL.

BLoch

The best way
to cheer yourself up
is to try to
cheer somebody else up.

—*Mark Twain*

ILLUSTRATION BY SERGE BLOCH

Trees are

much like human beings

and enjoy each other's company.

Only a few love

to be alone.

—*Jens Jensen*

ILLUSTRATION BY SELÇUK DEMIREL

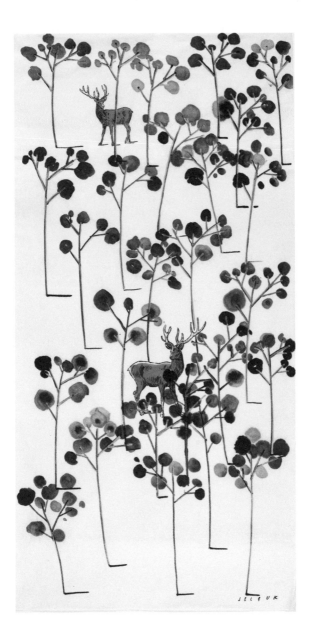

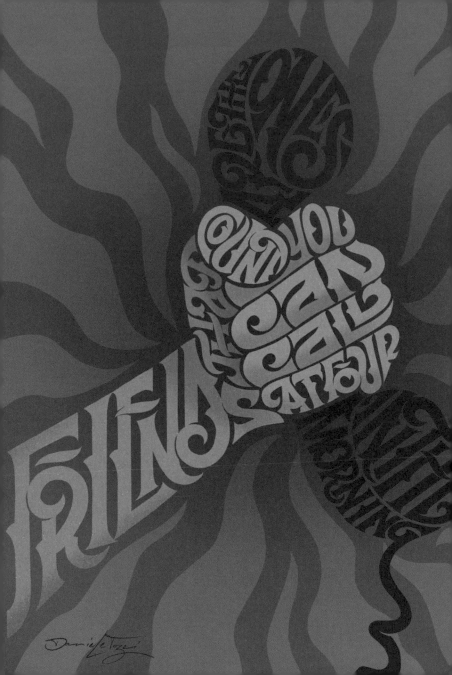

The friends that count
are the ones
you can call at 4 in the morning.

—*Marlene Dietrich*

ILLUSTRATION BY DANIELE TOZZI

Wasn't friendship
its own miracle,
the finding of another person
who made
the entire lonely world
seem somehow less lonely?

—*Hanya Yanagihara*

ILLUSTRATION BY FRANCESCO BONGIORNI

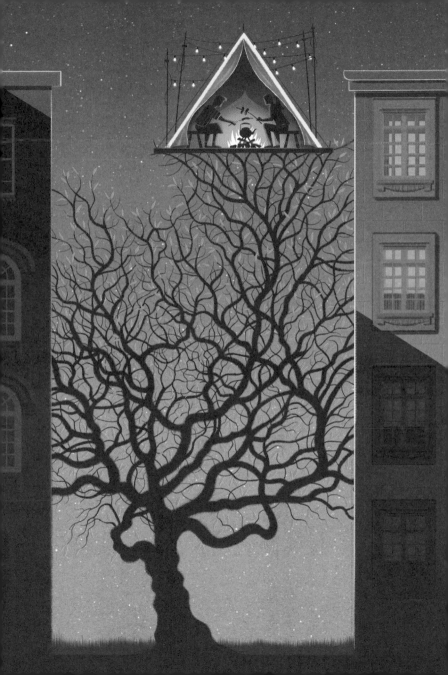

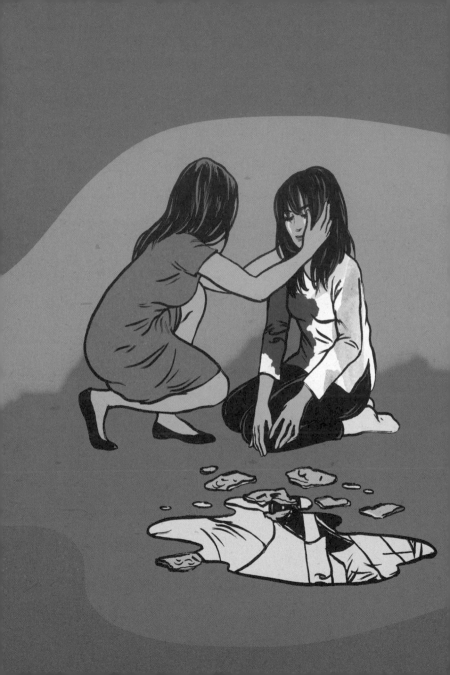

A true friend
never gets in your way
unless you happen to be
going down.

—*Arnold H. Glasow*

ILLUSTRATION BY AGATA NOWICKA

The bird a nest,

The spider a web,

Man friendship.

—William Blake

ILLUSTRATION BY FEDERICO JORDAN

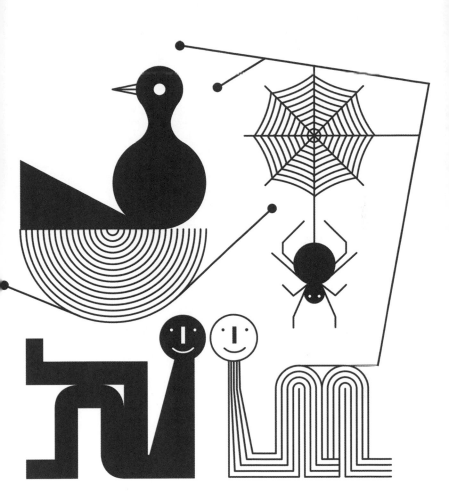

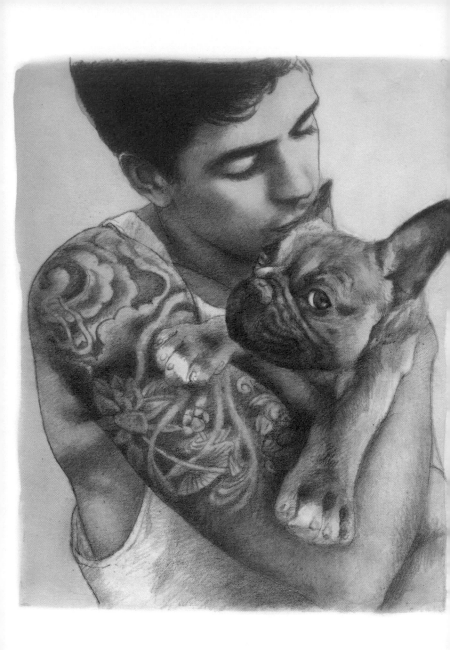

Each friend represents

a world in us,

a world possibly not born

until they arrive,

and it is only by this meeting

that a new world is born.

—Anaïs Nin

ILLUSTRATION BY ENRIQUE MOREIRO

If you have but one friend,
make sure you choose her well.

—*Muriel Barbery*

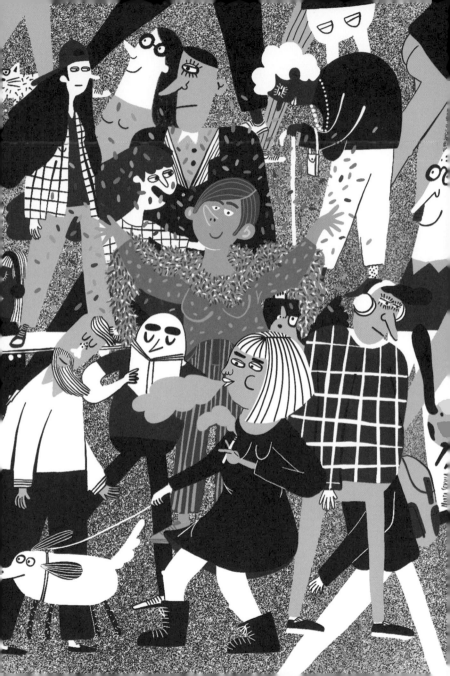

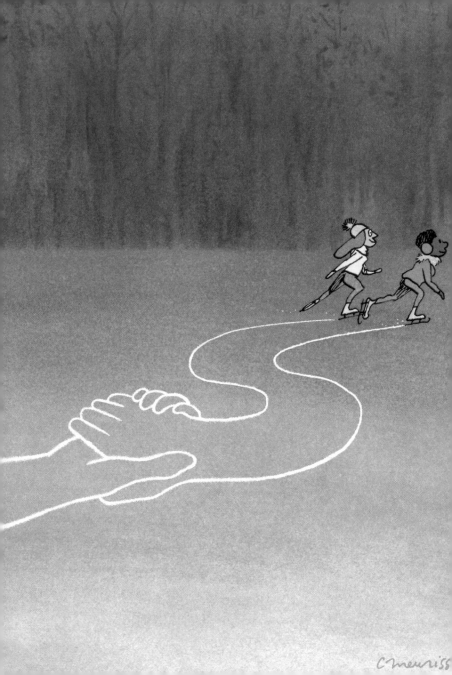

When friendships are real,

they are not glass threads

or frost work,

but the solidest things

we can know.

—*Ralph Waldo Emerson*

ILLUSTRATION BY CATHERINE MEURISSE

Without friends,
no one would want to live,
even if he had
all other goods.

—*Aristotle*

ILLUSTRATION BY LORENZO PETRANTONI

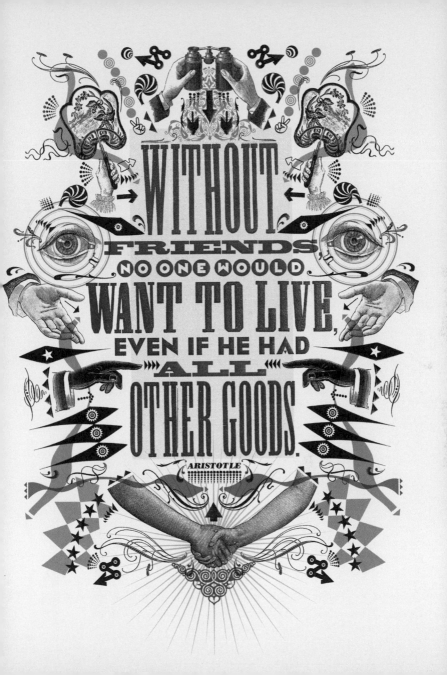

WITHOUT FRIENDS, NO ONE WOULD WANT TO LIVE, EVEN IF HE HAD ALL OTHER GOODS.

ARISTOTLE

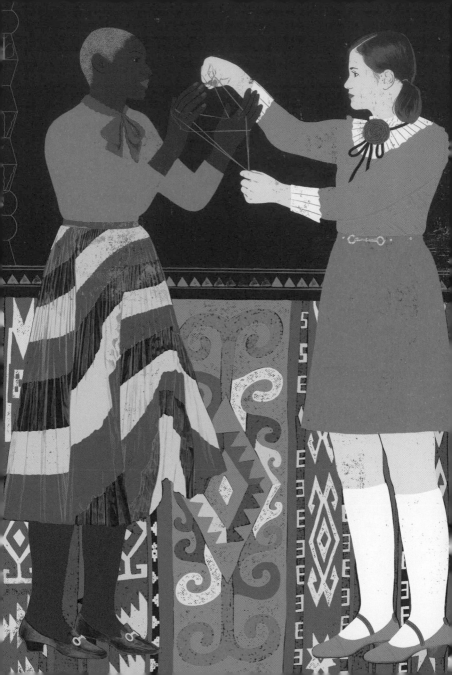

During the months
of confinement,
I missed my female friends;
the companionship,
the talks, the exchanges.

WORDS AND ILLUSTRATION BY SONIA PULIDO

True friendship
is a plant
of slow growth.

—*George Washington*

ILLUSTRATION BY KEVIN WHIPPLE

Friends are
the family
we choose ourselves.

—*Edna Buchanan*

Outside of a dog,
a book is a man's best friend.
Inside of a dog,
it's too dark to read.

—Groucho Marx

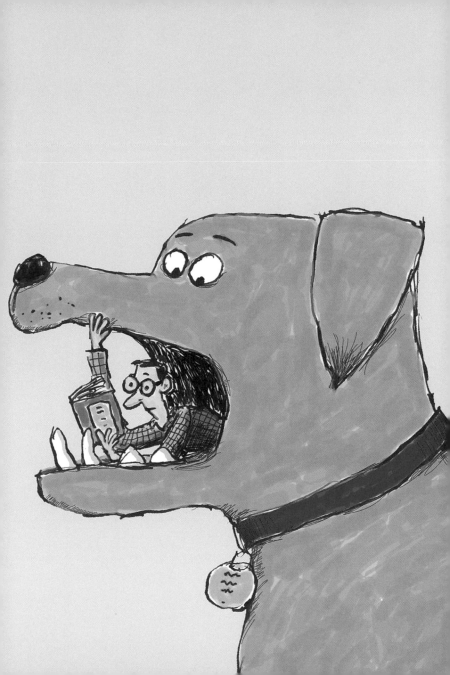

A warm, rainy day—this is how
it feels when friends get together.

Friend refreshes friend then,
as flowers do each other,
in a spring rain.

—*Rumi*

ILLUSTRATION BY JING LI

A good friend
is a connection to life—
a tie to the past,
a road to the future,
the key to sanity in a
totally insane world.

—*Lois Wyse*

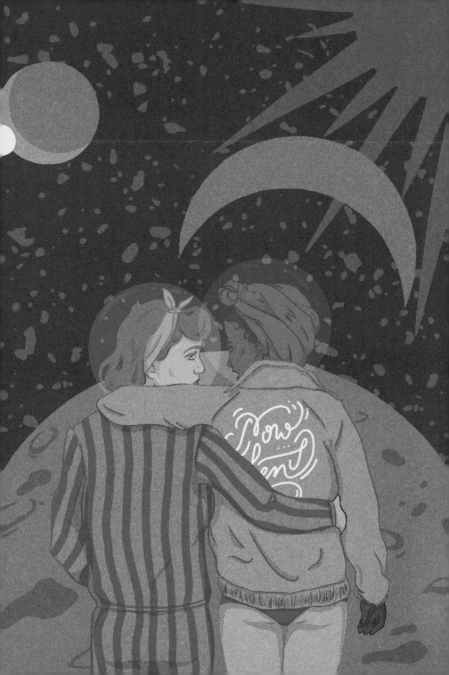

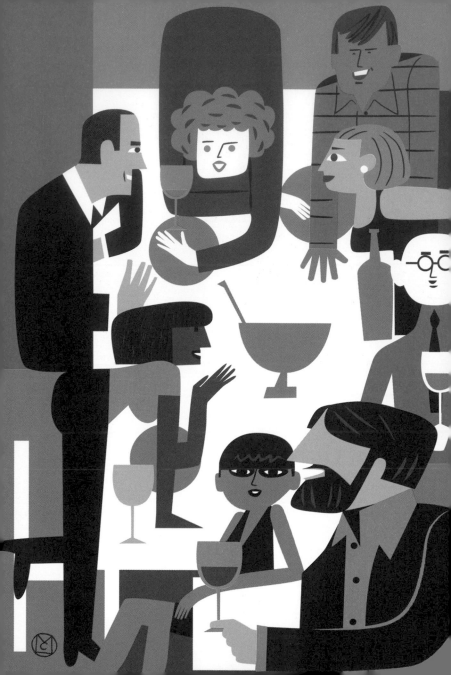

I'm from a place

where we celebrate friendship

around a tablecloth of white thread.

I'm from a place

where friendship is a

part of the present smiling,

of complicit and sincere looks.

I am from a place

where "dear friend" is *lagun maitea*,

but also *querido amigo*

and also *cher ami*.

I am from a place

where my friends are my homeland.

WORDS AND ILLUSTRATION BY MIKEL CASAL

高山流水覓知音，
子之心而與吾心同。—
《列子·湯問》

Lofty mountains
meet flowing water,
you know
the song in my heart.

—*Liezi*

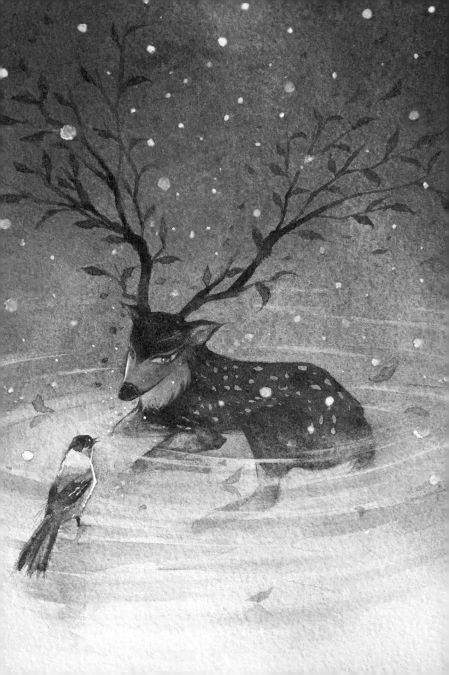

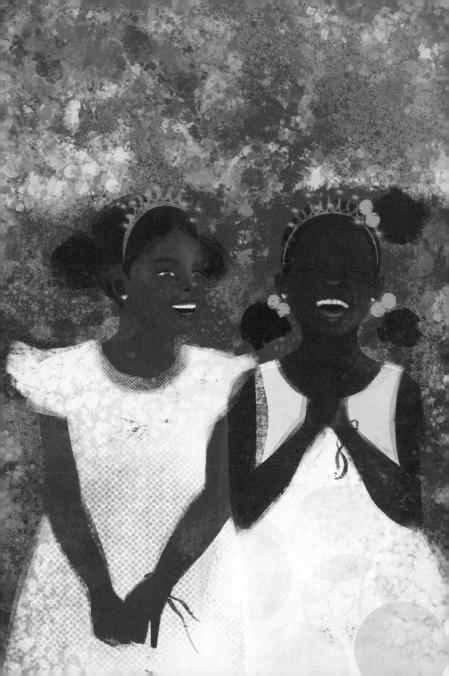

A good friend is someone
who loves you unconditionally—
a good listener
who holds your hand and
cheers you on through good times and bad,
and whose presence
stays with you always,
even after their death.

WORDS AND ILLUSTRATION BY ERIN ROBINSON

We can live without religion
and meditation,
but we cannot survive
without human affection.

—*Dalai Lama XIV*

ILLUSTRATION BY CAROLE HÉNAFF

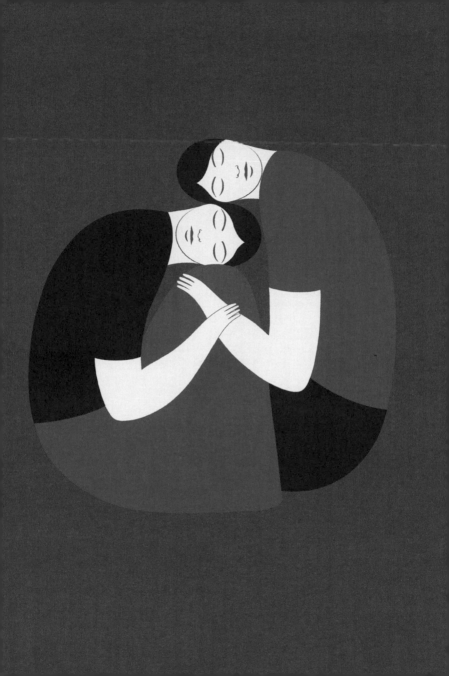

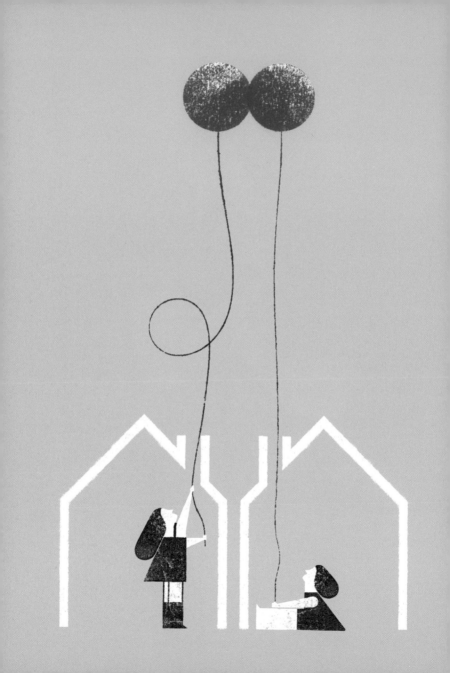

People are lonely

because they build walls

instead of bridges.

—*Joseph Fort Newton*

The sun and the moon

shared the horizon

in a distant friendship,

each unfazed by the other.

—Toni Morrison

ILLUSTRATION BY OLIMPIA ZAGNOLI

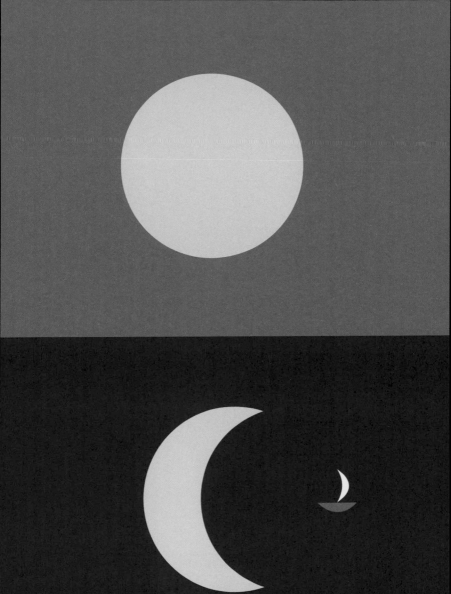

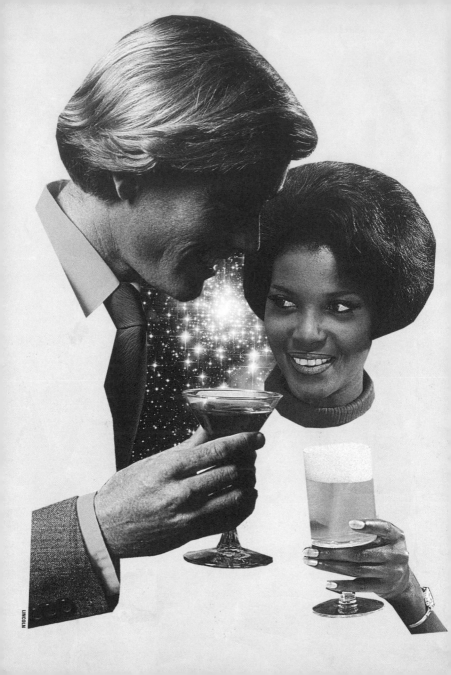
LINCOLN

In everyone's life, at some time,

our inner fire goes out.

It is then burst into flame

by an encounter with another human being.

We should all be thankful

for those people

who rekindle the inner spirit.

—*Albert Schweitzer*

ILLUSTRATION BY LINCOLN AGNEW

Don't walk in front of me,
I may not follow.
Don't walk behind me,
I may not lead.

Walk beside me,
just be my friend.

—*Unknown*

ILLUSTRATION BY EDMON DE HARO

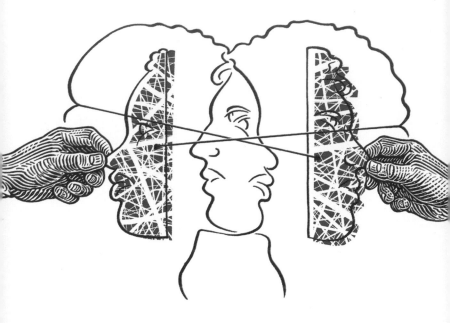

Once upon a time
two children had a friendship
that bound them so delicately together,
that they might have been living
cradled in the huge dreaming pads
of a great water lily. Then one day suddenly
their bond cracked and broke.
The magical time of childhood was over,
and two grown men stood there in their place,
enmeshed in a complicated
and enigmatic relationship commonly
covered by the word "friendship."

—*Sándor Márai*

ILLUSTRATION BY ISTVÁN OROSZ

Friendship isn't
a big thing.
It's a million little things.

—*Unknown*

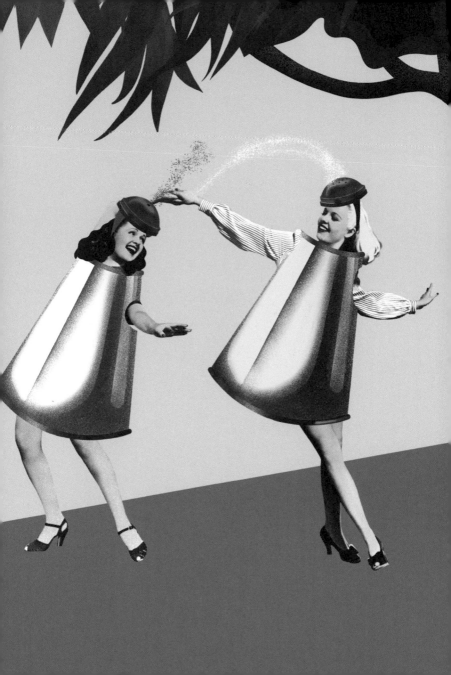

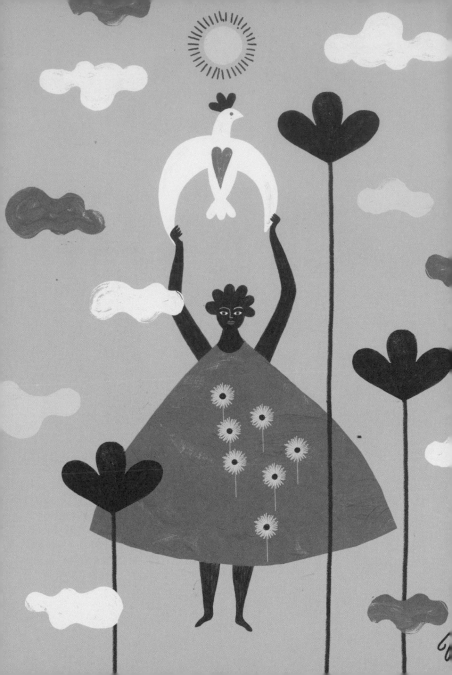

A sweet friendship

refreshes the soul.

—*Proverbs 27:9*

Like a sculptor, if necessary,

carve a friend out of stone.

Realize that your inner sight is blind

and try to see a treasure in everyone.

—Rumi

ILLUSTRATION BY JEROME CORGIER

LIKE

A SCULPTOR,

IF NECESSARY,

CARVE
A FRIEND

OUT OF STONE.

REALIZE THAT YOUR INNER

SIGHT
IS BLIND

AND TRY TO SEE A

TREASURE
IN EVERYONE.

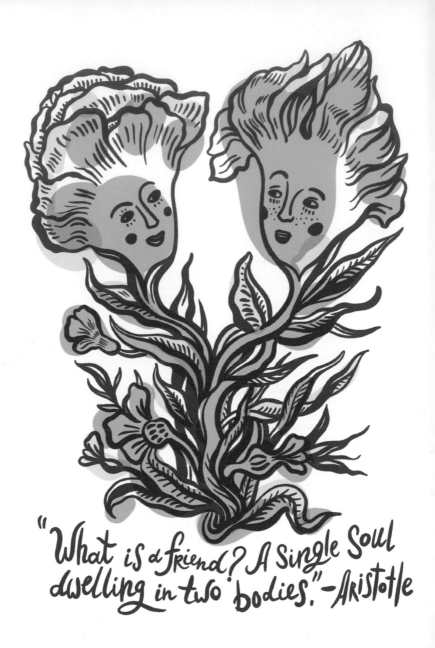

"What is a friend? A single soul dwelling in two bodies." —Aristotle

What is a friend?
A single soul
dwelling in two bodies.

—*Aristotle*

ILLUSTRATION BY NATALYA BALNOVA

I would rather walk
with a friend in the dark
than walk alone
in the light.

—*Helen Keller*

ILLUSTRATION BY ANNE-LISE BOUTIN

A friend is one
who overlooks your broken fence
and admires
the flowers in your garden.

—*Unknown*

ILLUSTRATION BY CARMEN SEGOVIA

I don't need a friend
who changes when I change
and who nods when I nod;
my shadow
does that much better.

—*Plutarch*

ILLUSTRATION BY OLA NIEPSUJ

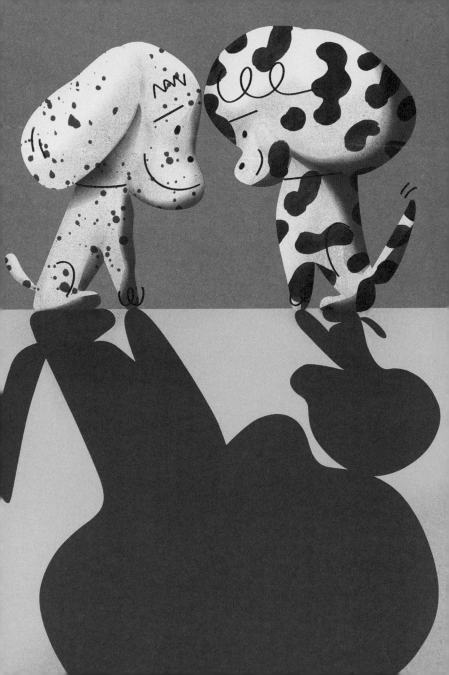

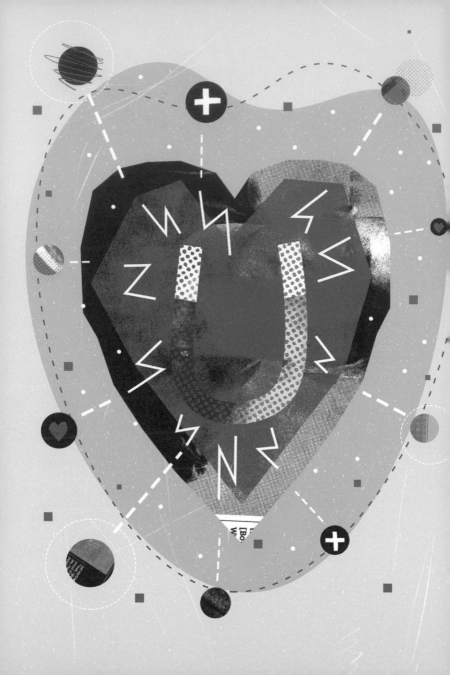

To have friends,
you must manifest friendliness.
If you open the door
to the magnetic power of friendship,
a Soul or Souls of like vibrations
will be attracted to you.

—*Paramahansa Yogananda*

ILLUSTRATION BY NATE KITCH

The greatest joy of life
is to have an opportunity
to express love.
That's the only reason
to create a friendship.

—Yaga Bialski

ILLUSTRATION BY MAGDA AZAB

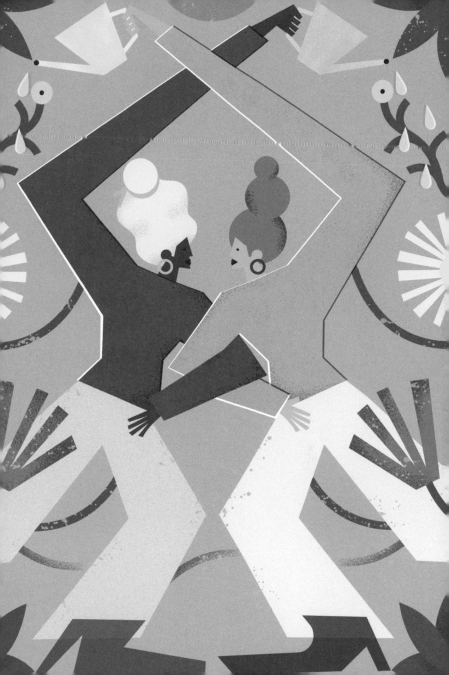

I let the dog out,

or I let him in,

and we talk some.

I let him know I like him,

and he lets me know

he likes me.

—*Kurt Vonnegut*

ILLUSTRATION BY HADLEY HOOPER

I think I have learned
that the best way
to lift one's self up
is to help some one else.

—*Booker T. Washington*

ILLUSTRATION BY ADRIÀ FRUITÓS

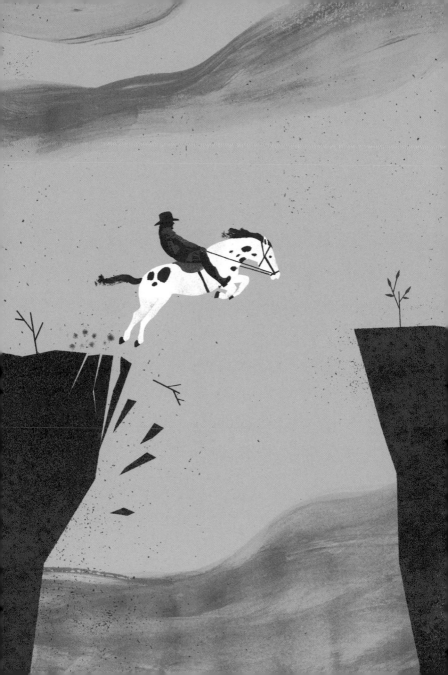

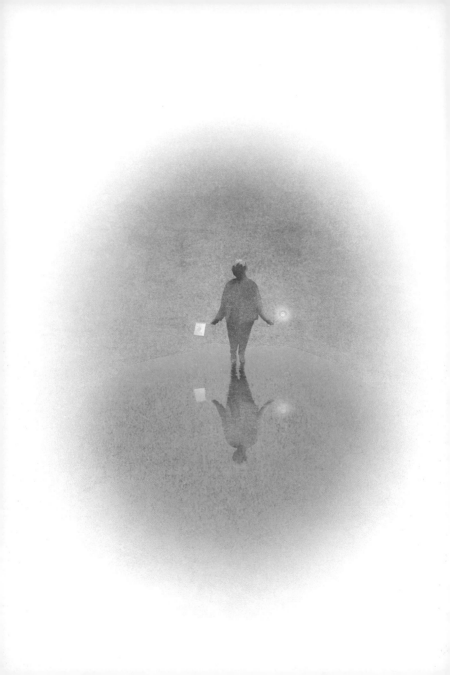

A friend is,
as it were,
a second self.

—Cicero

ILLUSTRATION BY MICHAEL WOLOSCHINOW

Animals are the bridge

between us and the beauty

of all that is natural.

They show us what's missing in our lives,

and how to love ourselves

more completely and unconditionally.

They connect us back to who we are,

and to the purpose

of why we're here.

—*Trisha McCagh*

ILLUSTRATION BY IRENE RINALDI

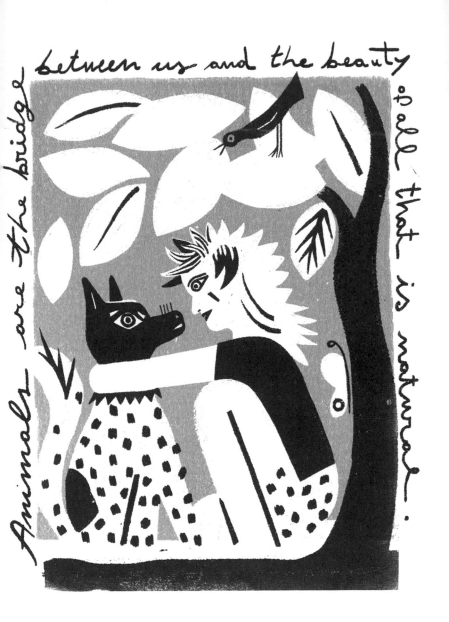

Animals are the bridge between us and the beauty of all that is natural.

Friendship
is the soul's heaven.

—Amos Bronson Alcott

Two may talk together
under the same roof for many years,
yet never really meet;
and two others at first speech
are old friends.

—*Mary Hartwell Catherwood*

ILLUSTRATION BY FRED BENAGLIA

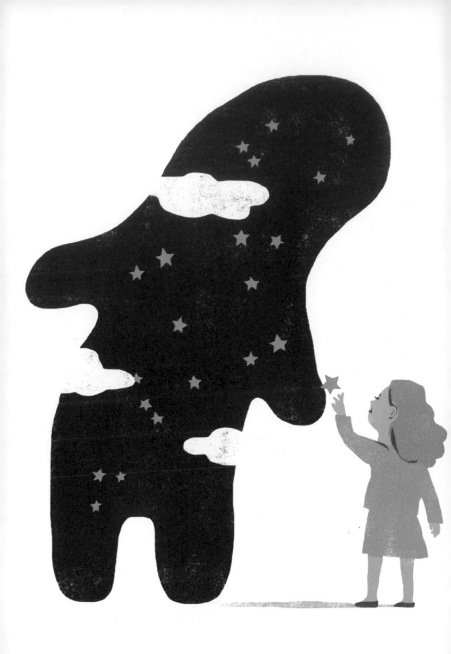

In love and friendship,
the imagination is as much exercised
as the heart.

—*Henry David Thoreau*

Growing apart
doesn't change the fact
that for a long time
we grew side by side;
our roots will always be tangled.
I'm glad for that.

—*Ally Condie*

ILLUSTRATION BY KASIA BOGDAŃSKA

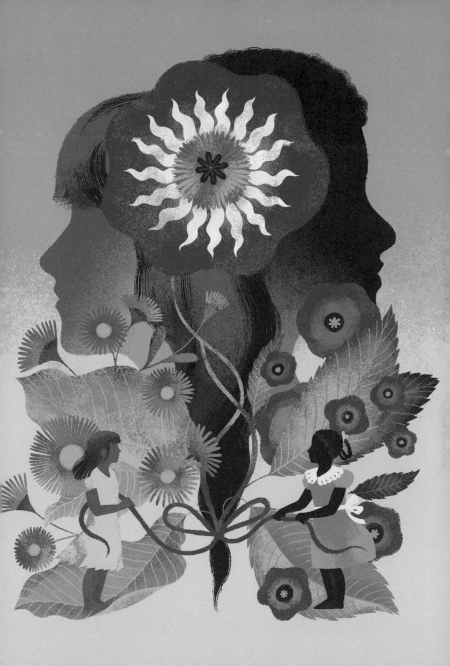

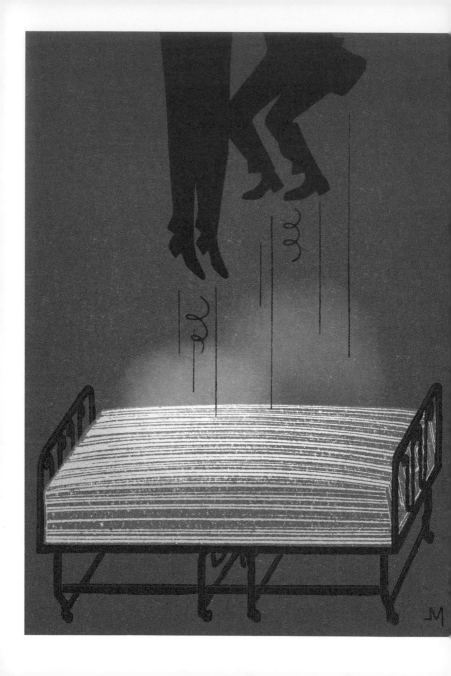

Je sais mieux
faire l'amitié
que l'amour.

I am better
at making friends
than making love.

—*Jean Cocteau*

ILLUSTRATION BY JEAN-FRANÇOIS MARTIN

Friends show
their love
in times of trouble,
not happiness.

—*Euripides*

ILLUSTRATION BY ELIZABETH MONTERO SANTA

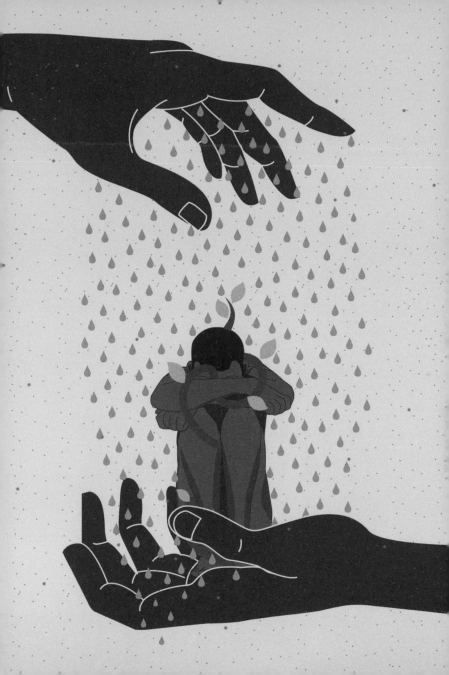

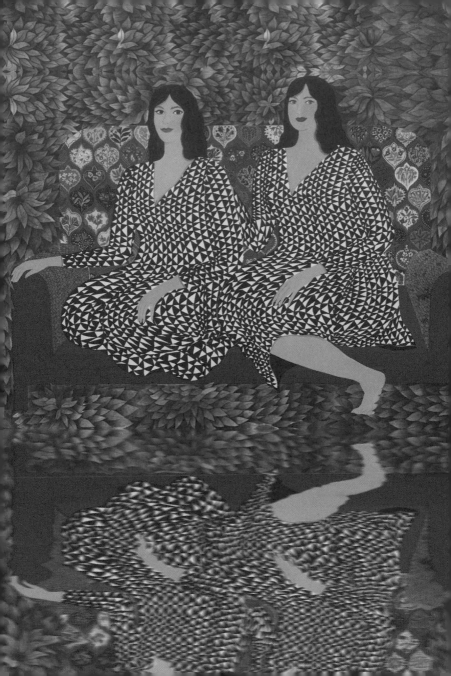

Friend! trouble not yourself
about your lot,
Let futile care and sorrow
be forgot;
Since this life's vesture crumbles into dust,
What matters stain of word
or deed, or blot?

—*Omar Khayyam*

ILLUSTRATION BY ATIEH SOHRABI

A true friend

is someone who thinks

that you are a good egg

even though he knows

that you are slightly cracked.

—*Bernard Meltzer*

ILLUSTRATION BY OLA JASIONOWSKA

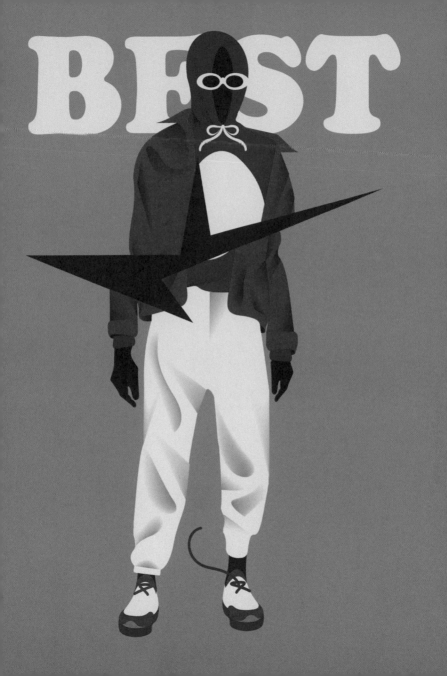

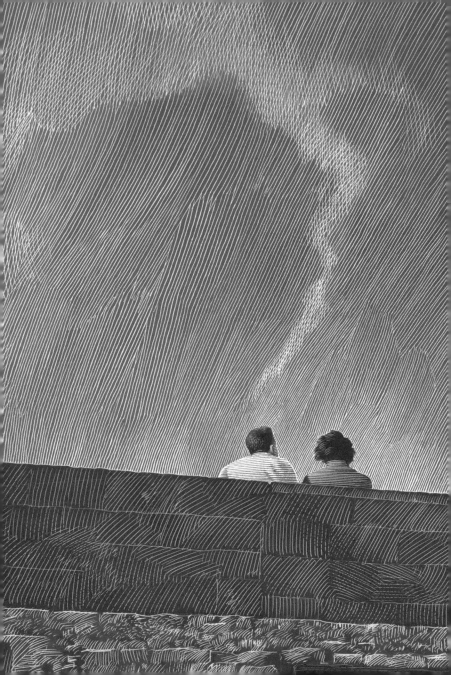

The glory of friendship
is not the outstretched hand,
not the kindly smile,
nor the joy of companionship;
it is the spiritual inspiration
that comes to one when you discover
that someone else believes in you
and is willing to trust you
with a friendship.

—*Ralph Waldo Emerson*

ILLUSTRATION BY SCOTT McKOWEN

One of the most
beautiful qualities
of true friendship
is to understand
and be understood.

—*Seneca*

ILLUSTRATION BY ANDRÉ DA LOBA

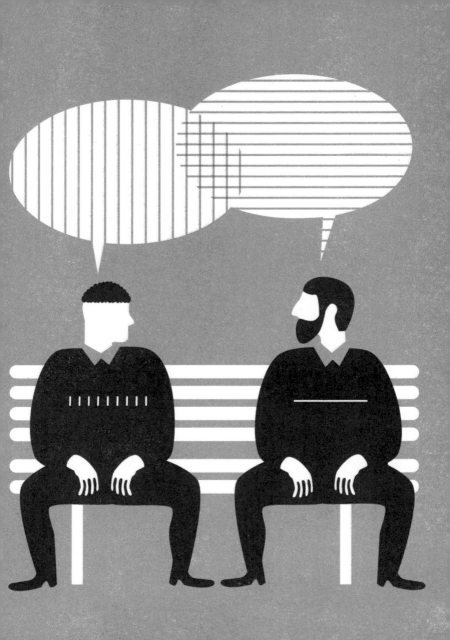

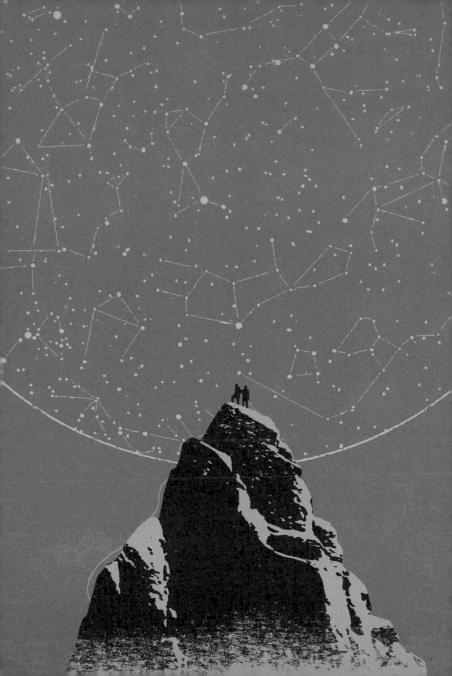

El més important,

entre dos amics,

són els moments de silenci.

The most important thing

between friends

is the moments of silence.

—Josep Maria Espinàs

With books, as with companions,
it is of more consequence
to know which to avoid,
than which to choose;
for good books are as scarce
as good companions.

—*Charles Caleb Colton*

ILLUSTRATION BY PAUL ZWOLAK

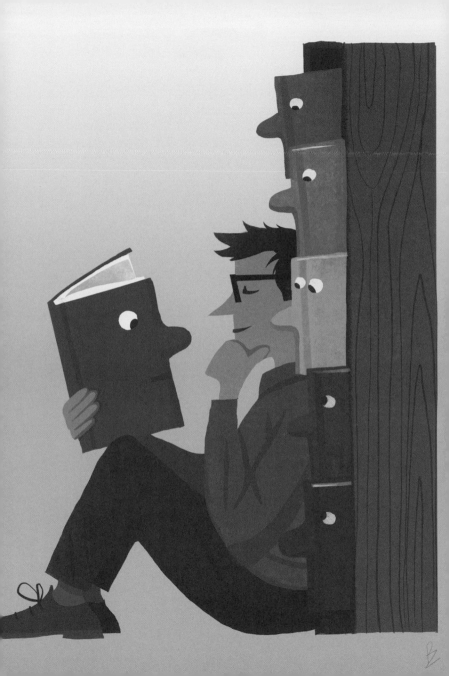

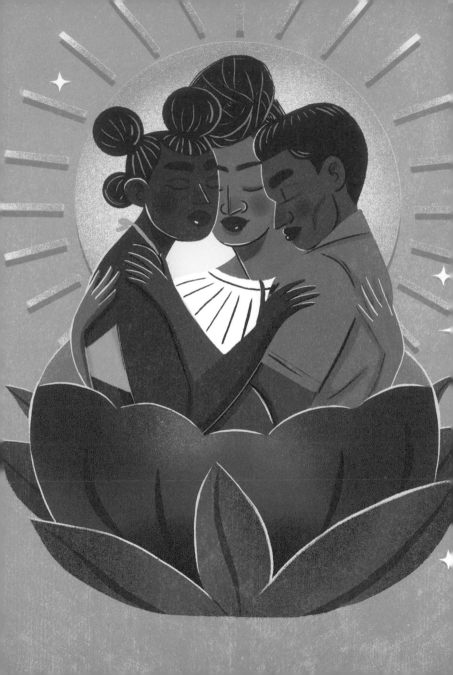

Friendship has splendors
that love knows not.
It grows stronger when crossed,
whereas obstacles kill love.
Friendship resists time,
which wearies and severs couples.
It has heights unknown to love.

—Mariama Bâ

ILLUSTRATION BY LYDIA MBA

When a friend
speaks to me,
whatever he says
is interesting.

—*Jean Renoir*

ILLUSTRATION BY TOMASZ WALENTA

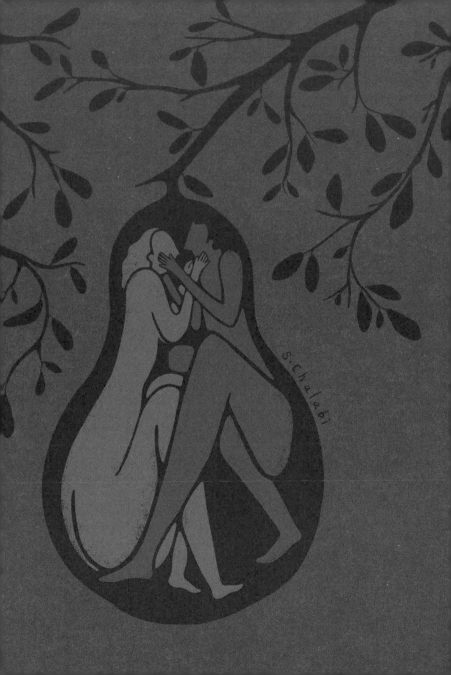

Wishing to be friends
is quick work,
but friendship
is a slow ripening fruit.

—*Aristotle*

Friends are those rare people
who ask how we are
and then wait to hear the answer.

—*Ed Cunningham*

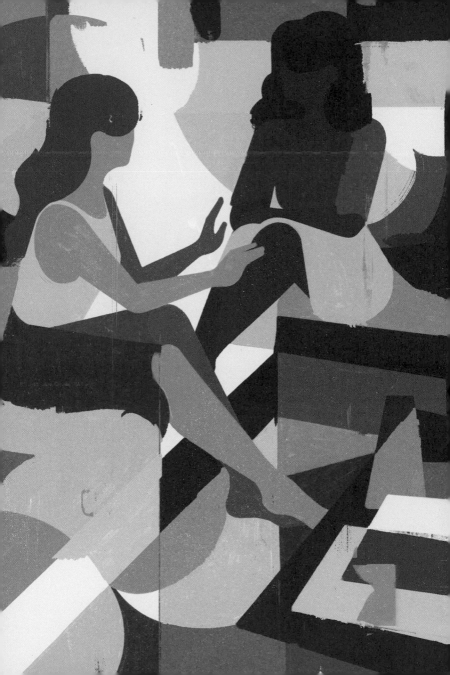

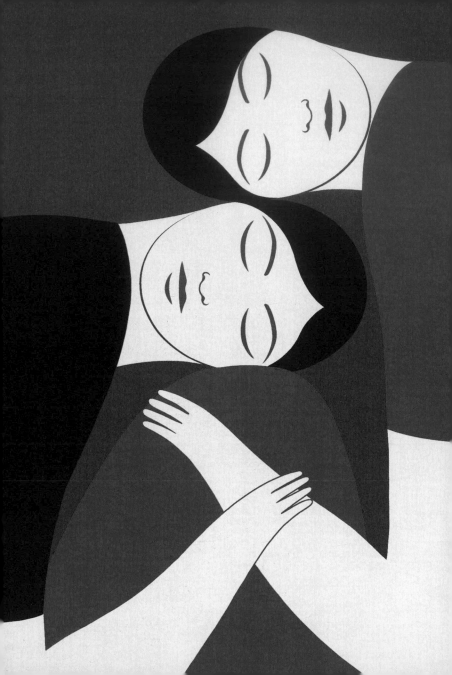

ARTISTS

The artists whose illustrations accompany the quotations in this book represent 15 different countries spanning the globe. They have won gold and silver medals from the Society of Illustrators and are regularly featured in the *Annual of American Illustration* and *Communication Arts*, among numerous other publications. They have produced art for clients including Apple, Google, the *New York Times*, the *Wall Street Journal*, the *New Yorker*, the *Washington Post*, the *Boston Globe*, Nickelodeon, the Guggenheim Museum, ProPublica, Lucasfilm, Clinique, Prada, Tiffany & Co., *Le Monde*, Taschen, World Wildlife Fund, Airbnb, Lincoln Center, New York City Opera, New York Public Radio, Wells Fargo, *TIME, Fast Company*, the Ford Foundation, and many others.

The artists are all represented by Marlena Agency. The agency's founder, Marzena Torzecka, brought many of them together to create *Ani Trime's Little Book of Affirmations*. For this book, she invited them to choose and illustrate a quotation about friendship. Some of the artists have also shared thoughts of their own about friendship, shown below their profiles on the following pages.

LINCOLN AGNEW is an illustrator based in Vancouver, Canada. When he isn't busy wandering through the woods or staring up at the clouds, he enjoys working with such publications as *Vanity Fair*, the *New York Times*, and *Rolling Stone*.

MAGDA AZAB is an Italian-Egyptian illustrator based near Milano, Italy. She works with clients from around the world on a wide range of projects, from editorial illustrations to animations, branding, and pattern design. Her recognizable style is a combination of colors, graphic elements, irony, and lateral thinking.

NATALYA BALNOVA is a New York–based illustrator, designer, and printmaker. She graduated from the MFA Illustration as Visual Essay program at the School of Visual Arts, and she received a BFA in communication arts from the Parsons School of Design, as well as a BFA in communication arts from the Academy of Industrial Art and Design in St. Petersburg, Russia.

MARTIN LEÓN BARRETO is an Uruguayan illustrator and graphic designer currently based in Madrid, Spain. Mostly focused on the editorial field, he illustrates for children as well as adults.

ADRIANA BELLET is an illustrator based in Stockholm, Sweden. Originally from Spain, with a Spanish dad and a German mum, she grew up between cultures. She studied creative advertising in Barcelona and lived for a short while in Berlin before moving to the UK in her early twenties. There she furthered her studies with a postgrad on surface design at the University of the Arts London, where she was first introduced to illustration.

FRED BENAGLIA is a children's book artist based in France. He illustrated *Hug This Book!* and *Twinkle, Twinkle, ABC* (Phaidon) for the US market and has illustrated multiple books for children in Europe, including the Adélidélo and Petit Dernier series.

SERGE BLOCH is a French illustrator born in 1956 in Colmar, France. He has been awarded several international prizes and gold medals in recognition of his work, and his books are internationally translated and published.

KASIA BOGDAŃSKA was born in 1980 and works as an illustrator in Warsaw, Poland, where she studied painting at the Academy of Fine Arts.

FRANCESCO BONGIORNI was born in Milan in 1984. He graduated from NABA (New Academy of Fine Arts) in 2006 and studied illustration at the European Institute of Design. He lives and works in Madrid.

FEDERICA BORDONI lives and works in Trento, a small town in northeastern Italy. Her illustrations, made mostly with digital techniques, are characterized by a minimalist and dreamlike style.

ANNE-LISE BOUTIN is a French artist who graduated from ESAA Duperré and from the Musée des Arts Décoratifs in Paris. She currently works on a regular basis for daily publications such as *Libération*, *Le Monde*, the *Guardian*, and the *New York Times*, and for various magazines.

MIKEL CASAL lives in San Sebastián, a coastal town in the north of Spain, where it is always rainy, even when it is not raining. His work has appeared in the *Guardian, Tatler,* the *Boston Globe,* and *Media Vaca*.

"S. is a woman. S. She is my friend. We all know the danger of losing a close and sweet friendship when trying to convert it into a loving relationship. We speculate on the impossibility or the difficulty of a deep friendship between a woman and a man. But what is friendship if not the purest expression of love, a long-lasting and desirable romantic love story? The approach of feminine and masculine sensibilities with respect and complicity within the framework of friendship is one of the most beautiful places I know. A place where my most sensitive and beloved moments are safe. A favorite place. S. and I are friends."

SAWSAN CHALABI is an illustrator and designer based in Washington, DC. She received her BA in graphic design from Notre Dame University in Beirut, Lebanon, and her MFA in illustration from Savannah College of Art and Design in Savannah, Georgia. Her clients include the *Washington Post*, the *LA Times*, Lee & Low Books, and Penguin Random House. Her work has been recognized by illustration annuals such as *3x3 Magazine* and *American Illustration*.

GARY CLEMENT has been the political cartoonist for Canada's *National Post* since its inception in 1998. His cartoons and illustrations have also appeared in the *New York Times*, the *Guardian*, the *Miami Herald*, and *TIME* magazine. His illustration work has appeared numerous times in *American Illustration*. He is also a children's writer and illustrator and is a three-time nominee for the Governor General's Literary Award for illustrated children's books.

JEROME CORGIER was born in 1983 in Orleans, France, and is the founder of the design studio Atelier Pariri.

"I think my friendships start with love at first sight: I first fall in love with my future friends, and it turns into friendship over time. And when that emotion is reciprocated, I think that's when it becomes solid!"

ANDRÉ DA LOBA is a published and exhibited artist from Portugal whose work has received international acclaim. As an illustrator, animator, graphic designer, sculptor, and educator, André's combination of curiosity, experience, knowledge, and the unknown serves as the constant medium with which he creates and inspires.

EDMON DE HARO was born in Barcelona in 1984. He is a freelance artist who focuses on concept illustration and visual communication. After graduating from the graphic design program at the Elisava school in Barcelona, he spent several years working on an innovation consultancy. He currently combines editorial projects with his position as visual conceptualization teacher at the LABASAD school.

"You ask me why we are friends. Good question (my friend).

Because we are similar. Because we are different. Because we love the truth. Because we can share long and comfortable silences. Because we keep wondering at the world's beauty. Because we really know our deepest thoughts and fears. Because we can talk without words. Because we laugh together. Because no matter how much time we haven't seen each other, when we meet it will feel like it was yesterday.

Our minds and lives change, but we will always be connected. Like when we were kids and we played all Saturday long. And time seemed to be infinite."

SELÇUK DEMIREL was born in Artvin, Turkey, in 1954 and has lived in Paris since 1978. French audiences know his work from *Le Monde*, *Le Monde diplomatique*, and *L'Obs*. His work has also been featured in the *Washington Post*, the *Wall Street Journal*, and the *New York Times*. His drawings are regularly exhibited and have been featured in more than 50 books, including collaborations with Orhan Pamuk, John Berger, and İlhan Berk.

GÉRARD DUBOIS studied graphic design in Paris and is now a freelance illustrator based in Montreal. His work has appeared in many major North American and European publications and several ad campaigns, as well as in more than 20 books. His illustrations have won many recognitions, including the Hamilton King Award and four gold medals from the Society of Illustrators. His book *Enfantillages* received a BolognaRagazzi Award. In 2018, he was included in a Great Canadian Illustrators stamp series issued by Canada Post.
"Like marmalade, friends are bitter, sweet, and sticky and come in different flavors."

ISABEL ESPANOL is a French illustrator who lives and works in Paris. Since her first memories of life, she was drawn to art, creating collages and drawing as a child. She regularly works with clients such as Amnesty International, the *Boston Globe*, *Elle* and *Elle International*, *Le Monde*, the *Wall Street Journal*, the *Washington Post*, the City Hall of Paris, and different ministries in France.

ADRIÀ FRUITÓS is based in Strasbourg, France. He attended La Massana Fine Arts School in Barcelona and HEAR (Haute école des arts du Rhin) in Strasbourg. Adrià always tries to have a funny but strong message and, if possible, to create engaged images that convey a positive political message. His clients include *TIME*, *Le Monde*, and the *New York Times*.

JOANNA GROCHOCKA is a Polish illustrator and visual artist specializing in editorial and book illustration. In 2019 she was honored with a silver medal in book illustration from the Society of Illustrators in New York. Joanna works with a wide range of editorial, art, and culture clients, and her art has been exhibited all around the world.

CAROLE HÉNAFF is a French illustrator and graphic designer based in Barcelona since 1994. She has illustrated many children's books including *The Enchanted Lute Player*, *The Boy Who Drew Mermaids*, *The Adventures of Achilles*, and *Ali Baba and the 40 Thieves*.

HADLEY HOOPER lives in Denver, Colorado, and works as an illustrator and painter.

JASU HU lives in China and the United States. She works for editorial clients, book publishers, and advertising agencies. She uses atmospheric and abstract visual metaphors for storytelling. She has done many illustrations for the *New York Times*, the *New Yorker*, and the *Washington Post*.

EDSON IKÊ is a Brazilian illustrator working for publishing companies, advertising agencies, and architecture firms.

OLA JASIONOWSKA is a Warsaw-based illustrator and graphic designer. She has worked as an art director at Warsaw City Hall since 2016, collaborating on key visuals for various city events. She often collaborates with theaters and museums in Poland to help their visual branding.

MARIKO JESSE was born in Japan, spent her childhood in Hong Kong, and was educated in the United Kingdom. She studied at Central Saint Martins in London.

"I like to say that I've known my best friend for longer than I've known my brother, because she and I were babies in cots next to each other before he was even born. She's basically my sister. We have very different personalities and have made contrasting life choices, but we grew up together, running in and out of each other's houses, and we'll always be there for each other, no matter what."

FEDERICO JORDAN (born 1969) lives and works in Saltillo, México. His career as a graphic artist has been going on for more than 25 years of uninterrupted work. His line of practice proposes a contemporary post-constructivist approach, through aesthetic sublimation and Mexican colorfulness. He does art interventions in the Mexican desert.

GWENDA KACZOR is an illustrator based in Denver, Colorado. She received a BFA from the ArtCenter College of Design in Pasadena, California.

NATE KITCH is from the United Kingdom, where he studied illustration at Southampton Solent University.

"My truest friends are the constants; they can be anywhere, but they are always by my side."

JING LI is from China. She has MFA degrees in illustration from Savannah College of Art and Design (2017) and Maryland Institute College of Art (2019). She focuses on children's books and editorial illustration.

ALBERTO LOT is a designer, illustrator, and animator based in Italy. He worked in advertising for several years for Leo Burnett and Condé Nast. He has been working freelance since 2016. He loves to create surprising images that tell a story.

MARYSIA MACHULSKA is a Polish illustrator and graphic designer based in Paris. She graduated with honors from the graphic design department of the Academy of Fine Arts in Warsaw in 2008. Since 2010 she has had her own freelance practice, specializing in illustration and graphic design, editorial illustrations, book covers, posters, identities, and the like.

JEAN-FRANÇOIS MARTIN was born in Paris in 1967. He works for book publishers and international press. He won the prestigious BolognaRagazzi Award in the fiction category in 2011.

LYDIA MBA was born in Madrid, Spain. Her mother is Spanish, and her father is from Equatorial Guinea. She attended Escuela Superior de Dibujo Profesional, earning a degree in illustration, and is currently based in London, England. She uses her work as a tool to represent diversity in art and has enjoyed working in book publishing, editorial, video game design, and advertising.

SCOTT McKOWEN trained at the University of Michigan School of Art in the mid-1970s. He is based in Stratford, Ontario, and is a dual US-Canada citizen. He works in scratchboard, an engraving medium in which white lines are drawn on a black background with an X-ACTO blade. Scott has established an international career specializing in theater posters and graphics for the performing arts.

CATHERINE MEURISSE studied literature and the arts at the École Estienne and the École nationale supérieure des Arts Décoratifs in Paris. A prolific designer, author, caricaturist, reporter, and illustrator of children's books, she has produced several acclaimed comic books. Elected to the Académie des Beaux-Arts in 2020, she is the first cartoonist to join the Institut de France, a prestigious institution protecting the arts and sciences.

ANDREA MONGIA is an Italian illustrator born in 1989. He graduated with a degree in illustration from the European Institute of Design in Rome and is cofounder of Studio Pilar.

"One of my closest friends when I was at high school is now living very far from me. We call each other every year just once, the day of our birthday. She was born just one day after me. We have a long conversation, catching up about our own lives, problems, and how things are changing. It's a tradition for us, a nice, funny way to keep our friendship going for more than 15 years now."

ELIZABETH MONTERO SANTA (La Flor del Tamarindo) is an Afro-feminist Dominican illustrator who currently resides in Barcelona. In her illustrations she seeks to represent black and Afro-descendant women through her own experiences.

"As the years have passed, I have realized how important best friends are—they are those people who are present no matter how tough the circumstances may be, people who never give up on you and always support you in your dreams. In my case, because I am a migrant person, my friends have become my family—they are the people who know me the most and who I trust the most, a support for which I will always be grateful."

PEP MONTSERRAT is a Catalan artist based in Barcelona who mainly illustrates editorial as well as working on book covers and children's books. His work has been recognized by the Society of Illustrators, Catalan Professional Illustrators Society, and the Spanish Ministry of Culture. He has taught for more than 20 years at the Escola Massana Centre d'Art i Disseny in Barcelona, a public school devoted to teaching design and arts as illustration.

"I chose a quote from the beloved Catalan writer J. M. Espinàs to send good vibes to M., one of my oldest friends, who is fighting a severe illness. We talk a lot, we listen a lot, we think a lot in a shared silence. We grew up together. And we'll continue to."

ENRIQUE MOREIRO studied fine arts at the Complutense University of Madrid. Since the mid-80s he has worked as a painter, a sculptor, an engraver, and an illustrator. He runs his atelier and lives in Spain.

"Our need of giving and receiving affection trespasses the borders of species. If we can't find it among our fellow humans, we'll develop bonds of trust and friendship with others. It all started thousands of years ago. This is perhaps one of those traits that make us more human, and we share it with our animal friends, for affection is no-man's-land."

OLA NIEPSUJ is a Warsaw-based illustrator and graphic designer. She won a silver medal at the Society of Illustrators in New York City.

"My best childhood friend Marta is the most patient person I've met in my life. She passed through my home every morning before school—same time—and waited uncomplaining for me to finish my breakfast. We ended up late to morning class almost every day, for more than a decade, but she never ever complained. She was a real-life baby Yoda! Not to mention she gave me the most comforting hug after my first-ever heartbreak— we were just 10 years old—I doubt I would have survived it without her."

AGATA NOWICKA is an illustrator and comics artist, and a creator of posters and book covers. Her works have been published in the Polish feminist magazine *Wysokie Obcasy*, the *New Yorker*, *TIME*, and the *New York Times*, and featured in Taschen's *Illustration Now!*, *American Illustration*, and *Communication Arts*.

MIGUEL ORDÓÑEZ studied illustration at the school of Arte No. 10 in Madrid, and graphic design at Central Saint Martins in London. His two books with Jimmy Fallon, *Your Baby's First Word Will Be Dada* and *Everything Is Mama,* were *New York Times* bestsellers. He lives in Madrid.

ISTVÁN OROSZ is a Hungarian painter, printmaker, graphic designer, and animated film director. He is known for his mathematically inspired works, impossible objects, optical illusions, double-meaning images, and anamorphoses. His geometric art, with its forced perspectives and optical illusions, has been compared to works by M.C. Escher.

LORENZO PETRANTONI was born in Genoa in 1970. His passion for graphic design and his fascination for the eighteenth century combine in his illustrations and videos. He uses images from textbooks and dictionaries dating back to that period, which he discovered while browsing booksellers. His distinctive and unmistakable illustrations give life back to words, images, events, and characters that would otherwise be forgotten.

MARIA PICASSÓ i PIQUER is a Catalan artist based in Barcelona. She graduated with a degree in architecture and soon left her office job to become a full-time illustrator. She combines her training in architecture and design with her love for observing and capturing human faces, distilling them down to their most recognizable essence. Her work can be found around the world in a variety of formats, from press to toys, from gig posters to clothing collections.

"Friendship is discovering the bliss of being yourself in the company of someone else."

ASIA PIETRZYK is a freelancing creative based in Stockholm, illustrating and designing for clients worldwide. Color, shapes, and composition play a prominent role in her work. Her illustrations have been published by Taschen, *Elle France*, *TIME*, the *Boston Globe*, the *Wall Street Journal*, and *Wired*, amongst many others, and she has worked with clients in the beauty and fashion industry.

SONIA PULIDO is an illustrator based in Barcelona, and she says she could not be anything else but an illustrator. She mostly works for newspapers and magazines and enjoys illustrating covers and books for adults, too. She won a gold medal at the Society of Illustrators in New York City.

"I met Ana almost 20 years ago. We were very young; we had many common interests; it was an intense friendship. There were times when we saw each other every day, then others when we didn't see each other for years. But there is an invisible thread that unites us, that is always there, and when we see each other, whether it's been days or years, there is always connection in the hug, and the conversation flows as if time had no importance. That is friendship for me. That connection."

IRENE RINALDI lives and works in Rome. She graduated with a degree in illustration from the European Institute of Design in 2007 and now works with Italian and international magazines.

ERIN ROBINSON is a fashion designer who trained as a fine artist at Parsons School of Design and the Corcoran School of the Arts and Design. Her day dreamy, magical style is inspired by travel, color, texture, the feminine shape, and the many shades of Brooklyn, New York.

CARMEN SEGOVIA lives and works in Barcelona. In addition to her illustration work, she creates short comic stories and other collaborative projects.

MARTA SEVILLA is an illustrator based in Spain. Her professional activities focus on editorial illustration, children's picture books, book covers, and surface design.

"My oldest friend is Elena. We met in kindergarten, we lived in the same neighborhood, we went to the same activities after school. We've been angry with each other many times, we've said terrible and sometimes true things, but we've also shared great moments of joy, many laughs, other friends, our first love stories, our first heartbreaks, our doubts, passions, and mistakes. We have lived on the same street and on other sides of the world. Sometimes we were very close, and sometimes we were far away. But as time goes by, all these stories and feelings that we've shared become more important each day and became a kind of rock that you feel that you can hold onto any time, even in the distance."

LASSE SKARBÖVIK was born in Norway and graduated from Berghs School of Communication. He lives in Stockholm, Sweden, and is a founder of Stockholm Illustration. He works as a freelance artist for clients around the world.

ATIEH SOHRABI is an Iranian-born illustrator currently based in Brooklyn who has been illustrating children's books, magazines, and book covers since 2002. She studied industrial design at Islamic Azad University in Tehran. Her clients include the *New York Times*, NPR, The Kitchn, Medium, and Scholastic. Her work has been shown in exhibitions around the world including the Biennial of Illustrations Bratislava and the Society of Illustrators in New York City.

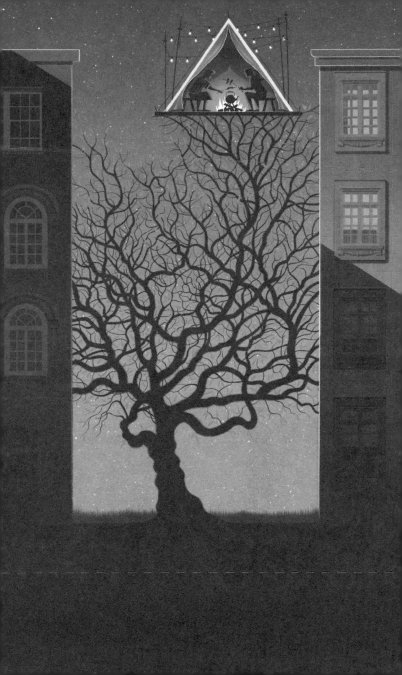

Wasn't friendship its own miracle,
the finding of another person who made the entire lonely world
seem somehow less lonely?
—*Hanya Yanagihara*

Wasn't friendship its own miracle,
the finding of another person who made the entire lonely world
seem somehow less lonely? —*Hanya Yanagihara*